assumes a more playful stance. By exploring the nuances and ambiguities of Magritte's visual critique of language, he finds the painter less removed than previously thought from the pioneers of modern abstraction—''confronting them and within a common system, a figure at once opposed and complementary.''

Foucault's brief but extraordinarily rich essay offers a startling, highly provocative view of a painter whose influence and popularity continue growing unchecked. *This Is Not a Pipe* also throws a new, piquantly dancing light on Foucault himself, particularly in relation to the brilliant early work, *Les Mots et les choses (The Order of Things)*.

D1087584

THIS IS NOT A PIPE

ABOUT
QUANTUM
BOOKS

QUANTUM, THE UNIT OF
EMITTED ENERGY. A QUANTUM
BOOK IS A SHORT STUDY
DISTINCTIVE FOR THE AUTHOR'S
ABILITY TO OFFER A RICHNESS OF
DETAIL AND INSIGHT WITHIN
ABOUT ONE HUNDRED PAGES
OF PRINT. SHORT ENOUGH TO BE
READ IN AN EVENING AND
SIGNIFICANT ENOUGH
TO BE A BOOK

Michel Foucault

This Is Not a Pipe

With Illustrations and Letters
by René Magritte

Translated and Edited
by James Harkness

University of California Press

Berkeley Los Angeles London

All paintings copyright 1982 by A.D.A.G.P., Paris

University of California Press
Berkeley and Los Angeles, California
University of California Press, Ltd.
London, England
© 1983 by The Regents of the
University of California

Library of Congress Cataloging in Publication Data

Foucault, Michel.
 This is not a pipe.
 Translation of Ceci n'est pas une pipe.
 Includes index.
 1. Magritte, René, 1898–1967. 2. Art—
Philosophy. I. Title.
ND673.M35F6813 759.9493 80-26627
ISBN 0-520-04232-8

Printed in the United States of America

 2 3 4 5 6 7 8 9

Contents

List of Plates

1. *L'Explication* (1952)
2. *La Condition humaine* (1935)
3. *Ceci n'est pas une pipe* (1926)
4. *Les Deux mystères* (1966)
5. *Tombeau des lutteurs* (1960)
6. *La Bataille de l'Argonne* (1959)
7. "Fumées," by Guillaume Apollinaire
8. "L'Oeillet," by Guillaume Apollinaire
9. Paul Klee, *Villa R* (1919)
10. Paul Klee, *The Wild Man* (1922)
11. Wassily Kandinsky, *White Balancing* (1944)
12. Wassily Kandinsky, *Improvisation: Green Center* (1935)
13. *L'Incendie* (1943)
14. *Le Séducteur* (1950)
15. *La Philosophie dans le boudoir* (1947)
16. *L'Art de la conversation* (1950)
17. *Le Soir qui tombe* (1934)
18. *Personnage marchant vers l'horizon* (1928–29)
19. *L'Alphabet des révélations* (1935)
20. *Perspective: Mme. Récamier* (1958)
21. *L'Usage de la parole* (1932)
22. *Représentation* (1962)
23. *Décalcomanie* (1966)
24. *Les Grâces naturelles* (1962)
25. *La Dame*, painted bottle (1943)

Acknowledgments

In translating and editing *This Is Not a Pipe*, I had the assistance of a number of persons I should like to thank here.

First and most important was Dr. Sarah Lawall, Professor of Comparative Literature at the University of Massachusetts, who guided my early study of Michel Foucault. She read each draft of the translation and gave inestimable help on the way to a completed manuscript. Dr. Lawall's wide knowledge and impeccable scholarship prevented several allusions from escaping unnoticed and greatly improved the overall quality of the translation. Her colleague, Dr. Roger Green of the French Department at the State University of New York at Albany, helped unravel a couple of the more complicated puns.

I am grateful to M. Bruno Roy, at Éditions fata morgana, for aiding in securing translation rights to the text of Michel Foucault's *Ceci n'est pas une pipe* (Montpellier: Éditions fata morgana, 1973). Mr. Harry Torczyner, representative of René Magritte's estate and attorney for A.D.A.G.P., helped me acquire permission to reproduce the paintings that illus-

trate the present volume, none of which were included in the French version. Mr. Torczyner also provided photographs of two Magritte canvases in his private collection.

I particularly appreciate the efforts of the following individuals for photographs of paintings: Mr. and Mrs. Nesuhi Ertegun; Mr. Eric Himmel, of Abrams Publishing Company; Ms. Hildagard Kron; Mme. René Magritte; Dr. Karin Frank v. Maur, of Staatsgalerie Stuttgart; Mme. Annette Minét, of Draeger, Maître Imprimeur; Mr. Richard Oldenburg and the research library staff of the Museum of Modern Art; M. Louis Scutenaire; and Mr. David Sylvester, of the Menil Foundation's René Magritte Catalogue Raisonné project.

Finally: to Dr. and Mrs. Clifton R. Wharton, Jr., my thanks for access to library and catalog resources, and for red-tape cutting par excellence. To Mr. William McClung of the University of California Press and my editor Ms. Marilyn Schwartz, my gratitude for able guidance and—above all—patience.

THIS IS NOT A PIPE

Translator's Introduction

Arguably the most durable of the Surrealist painters, René Magritte (1898–1967) was born in Lessines, Belgium. He was the oldest of three brothers in a petit bourgeois family that moved frequently: from Lessines to Gilly, Gilly to Châtelet, and (after the suicide of his mother) on to Charleroi, where he attended primary school and enrolled at the Athénée to study classics. In 1916 Magritte traveled to Brussels to enter the Académie des Beaux-Arts. He met classes irregularly, but he began to form friendships that would influence his career: Pierre Bourgeois, Pierre Flouquet, and E. L. T. Mesens.

Magritte had begun to paint as a boy of twelve. Much of the paraphernalia of the child's world would, in abstracted and alienated form, become the raw material of the adult's art: odd balloon shapes, umbrella stands, balustrades, and broken stone columns like those in a decaying cemetery where he played with other youngsters.

As a novice, Magritte experimented with Cubism, Futurism, and other styles, but it was his discovery of Giorgio de Chirico that seems to have electrified him.

De Chirico was an early or proto-Surrealist whose austere, rather cold compositions constituted the kind of visual non sequitur that the Comte de Lautréamont[1] had praised for being "as beautiful as . . . the fortuitous encounter upon an operating table of a sewing machine and an umbrella." In paintings such as de Chirico's *The Song of Love* Magritte claimed to have realized "the ascendancy of poetry over painting"—a revelation, according to Suzi Gablik, that moved him to tears.[2]

"The ascendancy of poetry over painting"—for the fact was that Magritte very early grew bored with painting as an end in itself. Once having settled upon a style, his most persistent concerns were diametrically opposed to those of painterly aestheticism. With the exception of a few interludes (notably the Fauvist "epoche vache" of 1948), after 1925 Magritte's methods grew virtually static. Despite the reproaches of some critics, formal and material problems lay almost wholly outside his realms of interest. He disliked being called an artist, preferring to be considered a thinker who communicated by means of paint. While many painters whose work holds philosophical implications are not self-consciously involved with "ideas," Magritte read widely in philosophy and listed among his favorite authors Hegel, Martin Heidegger, Jean-Paul Sartre—and Michel Foucault.

In the mid-1960s Magritte read Foucault's now famous *Les Mots et les choses*, known in English as *The Order of Things*. It was hardly surprising that the book would catch the painter's attention. The title was the same he had given an exhibition in New York City:

The relationship between words and things was precisely the theme so many of his canvases explored with startlingly disorienting effect.

How well Magritte knew Foucault's previous work is a matter for conjecture. Already an intellectual celebrity in Paris, Michel Foucault had won acclaim for his *Histoire de la folie* (translated in the United States as *Madness and Civilization*) and *Naissance de la clinique* (*Birth of the Clinic*). He had also written a penetrating appraisal of the Surrealist author Raymond Roussel, for whom Magritte seems to have felt an affinity. Broadly interested in the Surrealists, Foucault had composed highly original essays on such figures as Georges Bataille, whose collected works he had edited. Foucault and Magritte even exchanged letters, with two by Magritte reproduced in the present volume.

An early version of *Ceci n'est pas une pipe* appeared in 1968 in the journal *Les Cahiers du chemin*. Not until 1973 did Fata Morgana bring out an expanded edition of the essay in book form—possibly because the initial article had been attacked, as Bernard Noel remarks, by "virtually everyone."[3] It came at the apogee of structuralism, with which Foucault was loosely and unwillingly associated. Structuralist partisans and their antagonists were fighting strident, bloody battles across the pages of almost every French periodical, and it seems not unreasonable to guess that much of the initial disfavor that befell *Ceci n'est pas une pipe* was ideological in nature. With the passage of time, the critical reaction to Foucault's viewpoint has moderated, becoming more positive and certainly more evenhanded.

Magritte and Foucault must have recognized in one another a common fascination with what I earlier gave the inadequate label of visual non sequiturs, and which Foucault himself has dubbed *heterotopias*. From a passage in Borges, Foucault explains in *Les Mots et les choses*, he was led to a strange suspicion

that there is a worse kind of disorder than that of the *incongruous*, the linking together of things that are inappropriate; I mean the disorder in which a large number of possible orders glitter separately, in the lawless and uncharted dimension of the *heteroclite*; and that word should be taken in its most literal etymological sense; in such a state, things are "laid," "placed," "arranged" in sites so very different from one another that it is impossible to find a common place beneath them all. *Utopias* afford consolation: although they have no real locality there is nevertheless a fantastic, untroubled region in which they are able to unfold; they open up cities with vast avenues, superbly planted gardens, countries where life is easy, even though the road to them is chimerical. *Heterotopias* are disturbing, probably because they secretly undermine language, because they make it impossible to name this *and* that, because they shatter or tangle common names, because they destroy syntax in advance, and not only the syntax with which we construct sentences but also that less apparent syntax which causes words and things (next to but also opposite one another) to "hang together." This is why utopias permit fables and discourse: They run with the very grain of language and are part of the fundamental dimension of the *fabula*; heterotopias . . . dessicate speech, stop words in their tracks, contest the very possibility of language at its source; they dissolve our myths and sterilize the lyricism of our sentences.[4]

As cartographers of Heterotopia, both Foucault and Magritte engage in a critique of language—the former historico-epistemological, the latter visual. Each in his way concurs with the linguist Ferdinand de Saussure in asserting the arbitrariness of the sign— that is, the essentially circumstantial, conventional, historical nature of the bond between the signifier (e.g., a word) and the signified (the object or concept represented). In Saussurean linguistics, words do not "refer" to things themselves. Rather, they have meaning as points within the entire system that is a language—a system, further, conceived as a network of graded differences. "Dog" is not somehow attached to the real animal, arising naturally from it and participating magically in its essence or presence. Instead, "dog" has conceptual signification insofar as it evokes an idea that differs from the idea of a cat, a bear, a fur seal, etc. It has syntactical signification insofar as it (a noun) differs from words such as "bark" (verb) or "furry" (adjective) and thus cannot take their places in a proposition; and it has phonetic signification insofar as it differs from more or less similar sounding signifiers such as "bog," "dot," "dig," and so on.

From the commonsense vantage this seems an unnecessarily complex and circumlocutory approach to language, aimed at the most radical divorce possible between words and things. And why bother? After all, would anyone seriously argue that a word *is* what it represents—that the painting of a pipe is the pipe itself? Must we say rhetorically, with Foucault: "My God, how simpleminded!" Yet it is exactly from the commonsense vantage that, when asked to identify

the painting, we reply "It's a pipe"—words we shall choke on the moment we try to light up.

Nor is the confusion of words with things merely a minor mix-up, an easily remedied accident of everyday conversation. From antiquity to the present, persistent strains of Western thought have conceived the bond between language and reality as fundamentally mystical, a mutual sharing of essences. In the Old Testament, the Word is the Beginning (of Creation). For the Greeks, *Logos* connoted both reality and the knowledge (hence expressibility) of reality. Up to the end of the sixteenth century A.D., Europe remained trapped within a nostalgia for what it dreamed of as the language of Adam. Given directly by God (and persisting, perhaps, in the queer spatial figurations of written Hebrew), primordial language was a transparent duplication of the Universe,

an absolutely certain and transparent sign for things, because it resembled them. The names of things were lodged in the things they represented, just as strength is written in the body of the lion, regality in the eye of the eagle, just as the influence of the planets is marked upon the brows of men: by the form of similitude.

After Babel, the literal reciprocity of language and the world was destroyed; even so, language was not definitively severed from what it represented.

True, it is no longer nature in its primal visibility, but neither is it a mysterious instrument with powers known only by a few privileged persons. It is rather the figuration of a world redeeming itself, lending its ear at last to the true

word. . . . The relationship of languages to the world is one of analogy rather than signification; or rather, their value as signs and their duplicating function are superimposed; they speak the heaven and the earth of which they are the image; they reproduce in their most material architecture the cross whose coming they announce—that coming which established its existence in turn through the Scriptures and the Word.[5]

Even with the arrival of the Renaissance, Christian Europe continued to give the Word—religious revelation—precedence over both reason and the evidence of the senses as final index of the Real. During the Enlightenment, *les philosophes* often regarded words and things as more than artifically linked, witness the prominence of onomatopoeia and the principle of "similitude" in the abundant universal language schemes of the period. In the nineteenth century, Romanticism's intense aesthetics (especially in the poetry of Mallarmé) conferred upon the Word a mystical substantiality affording the writer new stature as heir to the religious visionary and the epic hero. In our own day, finally, a complex, mathematicized, but still recognizable variation on the theme lies in the work of the Cartesian linguist Noam Chomsky.

The mystical, Platonic identification of words with the essences of things is what many of Magritte's canvases vigorously assault. Just as in Saussurean linguistics words do not "refer" to things, in Magritte's Surrealism the painter's images do not really "resemble" anything whose sovereign presence would lend it the aspect of a model or origin. When

we say one thing resembles another, after all, we imply that the latter is somehow ontologically superior to, more "real" than the former—the copy predicates its existence (*qua* copy) upon whatever it submissively imitates. Major schools of traditional Western thought were unable definitively to separate language from its objects. Similarly, classical painting—using techniques ranging from perspective to *trompe-l'œil*—attempted to identify scenes or images with the "models" that inspired them. As Foucault notes, however, such a theory of representation reintroduced discursive affirmation into a space from which it had supposedly been ejected. Into the painting, in theory an exclusively visual production, there creeps a secret, inescapably linguistic element: "This painted image *is* that thing."

How to banish resemblance and its implicit burden of discourse? Magritte's strategy involves deploying largely familiar images, but images whose recognizability is immediately subverted and rendered moot by "impossible," "irrational," or "senseless" conjunctions. In *L'Explication* (1952), the most obvious thing about the carrot metamorphosing into the wine bottle is that it *is not* (does not reproduce, represent, or linguistically affirm) any actual carrot or bottle. The mimetic overflowing of the inner canvases in the *Condition humaine* series is so perfect that we automatically understand they have nothing to do with actual paintings or landscapes. No real frame conforms to the reflection of a body with the active sensuality of *Représentation* (1962)—and so on.

Despite his belief in "the ascendancy of poetry over painting," thus, Magritte's subversive enterprise falls

well within the antilinguistic program of modernism. From Klee and Kandinsky forward, modern art declares that a painting is nothing other than itself, autonomous from the language that lies buried in representational realism. But while the predominant mode for modernism's declaration of independence has been abstraction, Magritte uses literalism to undermine itself. In view of its striking bearing here, consider the following passage from *Les Mots et les choses*—elicited by another work by another artist, but equally germane for Magritte: .

the relation of language to painting is an infinite relation. It is not that words are imperfect or that, when confronted by the visible, they prove insuperably inadequate. Neither can be reduced to the other's terms: it is in vain that we say what we see; what we see never resides in what we say. And it is in vain that we attempt to show, by the use of images, metaphors, or similes, what we are saying; the space where they achieve their splendor is not that deployed by our eyes but that defined by the sequential elements of syntax. And the proper name, in this context, is merely an artifice: it gives us a finger to point with, in other words, to pass surreptitiously from the space where one speaks to the space where one looks; in other words, to fold one over the other as if they were equivalents.[6]

Foucault accounts for the simultaneously familiar and nonrepresentational quality of Magritte's images by drawing a distinction between *resemblance* and *similitude*. Resemblance, says Foucault, "presumes a primary reference that prescribes and classes" copies on the basis of the rigor of their mimetic relation to itself. Resemblance serves and is dominated by repre-

sentation. With similitude, on the other hand, the reference "anchor" is gone. Things are cast adrift, more or less like one another without any of them being able to claim the privileged status of "model" for the rest. Hierarchy gives way to a series of exclusively lateral relations: "similitude circulates the simulacrum as the indefinite and reversible relation of the similar to the similar." Painting becomes an endless series of repetitions, variations set free from a theme.[7]

To date, Foucault has been inconsistently served by his several translators, save Alan Sheridan. I hope to have avoided at least the worst failures of the past. Readers who compare the present version to the French text may notice that I have made some unconventional choices. In most cases the reasons will be evident, I think, if not universally convincing. Here I shall mention only a few general rules. Since the indicative function of articles and demonstratives varies considerably between French and English, I have tried to avoid what would sound like a stilted academicism by often rendering *ce* as *the* rather than *this*. Likewise, *qui* at times appears as *that* rather than *which*, following English usage for restrictive versus nonrestrictive modifying clauses.

Readers will find numerous references to particular words painted by Magritte into the fields of various works. In such cases, the words' material and figurative aspects are as important as their significations; consequently I have left them untranslated in the text and have given the English meanings in footnotes. I have done the same for the titles of paintings, largely as a matter of personal taste.

One problem in translating Foucault is that of preserving a sense of the author's wit.[8] Foucaultian laughter is present even in his most serious works, albeit usually in rather mordant tones. *Ceci n'est pas une pipe* introduces a less familiar humor, a playful, punning voice narrating a kind of analytical cartoon. It is a cornucopia of wordplays, wisecracks, and slapstick repetitions, many of which are either untranslatable or else require so much explanation as to be tedious. I have footnoted one or two instances where getting the joke is necessary for following the argument; elsewhere I have allowed the humor to escape rather than belabor it—not a happy solution, perhaps no solution at all. In most of Foucault's work word games are ubiquitous; in *Ceci n'est pas une pipe* they are what leaven the abstractions, prevent the minutiae from becoming oppressive, and guarantee the essay's fidelity to the insouciance of Magritte's own art.

All of which poses a final question: To what degree *does* Foucault's pipe remain faithful to Magritte's? For the modern art critic or historian, I strongly suspect that much of Foucault's investigation will appear suspect. Did classical painting, for example, really attempt to establish itself "entirely outside language"? Is Paul Klee's work truly rooted in breaking down the separation between linguistic signs and graphic shapes? Or Kandinsky's in rupturing the equivalence between resemblance and affirmation? Can Magritte's work be understood as continuing the same subversion?

Surely many readers will choose to disagree. But traditional hermeneutics are neither Foucault's aim

nor his interest. Indeed, the offhandedness with which he discards accepted ideas in favor of new, provisional, often highly provoking ones is the basis for what some people find most compelling in his work, as well as for what others find most infuriating.

Yet it is also true that to disregard the letter of the law is sometimes to preserve its spirit. As this little book so amusingly demonstrates, the effacement of bonds and the celebration of difference are certainly near the center of Magritte's art. Ultimately, thus, *Ceci n'est pas une pipe* both escapes from and yet returns to its "subject" by a willful self-liberation from anything upon which it might be obliged slavishly to "comment." Or as Foucault notes elsewhere, "The death of interpretation is to believe that there are signs, signs that exist primally, originally, really, as coherent, pertinent, and systematic marks. . . . The life of interpretation, on the contrary, is to believe that there are only interpretations."

James Harkness
Watervliet, New York
July 1981

This Is Not a Pipe

1

Two Pipes

The first version, that of 1926 I believe: a carefully drawn pipe, and underneath it (handwritten in a steady, painstaking, artificial script, a script from the convent, like that found heading the notebooks of schoolboys, or on a blackboard after an object lesson[1]), this note: "This is not a pipe."

The other version—the last, I assume—can be found in *Aube à l'Antipodes*.[2] The same pipe, same statement, same handwriting. But instead of being juxtaposed in a neutral, limitless, unspecified space, the text and the figure are set within a frame. The frame itself is placed upon an easel, and the latter in turn upon the clearly visible slats of the floor. Above everything, a pipe exactly like the one in the picture, but much larger.

The first version disconcerts us by its very simplicity. The second multiplies intentional ambiguities before our eyes. Standing upright against the easel and resting on wooden pegs, the frame indicates that this is an artist's painting: a finished work, exhibited and bearing for an eventual viewer the statement that comments upon or explains it. And yet this naive

handwriting, neither precisely the work's title nor one of its pictorial elements; the absence of any other trace of the artist's presence; the roughness of the ensemble; the wide slats of the floor—everything suggests a blackboard in a classroom. Perhaps a swipe of the rag will soon erase the drawing and the text. Perhaps it will erase only one or the other, in order to correct the "error" (drawing something that will truly not be a pipe, or else writing a sentence affirming that this indeed is a pipe). A temporary slip (a "mis-writing" suggesting a misunderstanding) that one gesture will dissipate in white dust?

But this is still only the least of the ambiguities; here are some others. There are two pipes. Or rather must we not say, two drawings of the same pipe? Or yet a pipe and the drawing of that pipe, or yet again two drawings each representing a different pipe? Or two drawings, one representing a pipe and the other not, or two more drawings yet, of which neither the one nor the other are or represent pipes? Or yet again, a drawing representing not a pipe at all but another drawing, itself representing a pipe so well that I must ask myself: To what does the sentence written in the painting relate? "See these lines assembled on the blackboard—vainly do they resemble, without the least digression or infidelity, what is displayed above them. Make no mistake; the pipe is overhead, not in this childish scrawl."

Yet perhaps the sentence refers precisely to the disproportionate, floating, ideal pipe—simple notion or fantasy of a pipe. Then we should have to read, "Do not look overhead for a true pipe. That is a pipe dream. It is the drawing within the painting, firmly

and rigorously outlined, that must be accepted as a manifest truth."

But it still strikes me that the pipe represented in the drawing—blackboard or canvas, little matter—this "lower" pipe is wedged solidly in a space of visible reference points: width (the written text, the upper and lower borders of the frame); height (the sides of the frame, the easel's mounts); and depth (the grooves of the floor). A stable prison. On the other hand, the higher pipe lacks coordinates. Its enormous proportions render uncertain its location (an opposite effect to that found in *Tombeau des lutteurs,*[3] where the gigantic is caught inside the most precise space). Is the disproportionate pipe drawn in front of the painting, which itself rests far in back? Or indeed is it suspended just above the easel like an emanation, a mist just detaching itself from the painting—pipe smoke taking the form and roundness of a pipe, thus opposing and resembling the pipe (according to the same play of analogy and contrast found between the vaporous and the solid in the series *La Bataille de l'Argonne*[4])? Or might we not suppose, in the end, that the pipe floats behind the painting and the easel, more gigantic than it appears? In that case it would be its uprooted depth, the inner dimension rupturing the canvas (or panel) and slowly, in a space henceforth without reference point, expanding to infinity?

About even this ambiguity, however, I am ambiguous. Or rather what appears to me very dubious is the simple opposition between the higher pipe's dislocated buoyancy and the stability of the lower one. Looking a bit more closely, we easily discern that the feet of the easel, supporting the frame where the can-

vas is held and where the drawing is lodged—these feet, resting upon a floor made safe and visible by its own coarseness, are in fact beveled. They touch only by three tiny points, robbing the ensemble, itself somewhat ponderous, of all stability. An impending fall? The collapse of easel, frame, canvas or panel, drawing, text? Splintered wood, fragmented shapes, letters scattered one from another until words can perhaps no longer be reconstituted? All this litter on the ground, while above, the large pipe without measure or reference point will linger in its inaccessible, balloon-like immobility?

2

The Unraveled Calligram

Magritte's drawing (for the moment I speak only of the first version) is as simple as a page borrowed from a botanical manual: a figure and the text that names it. Nothing is easier to recognize than a pipe, drawn thus; nothing is easier to say—our language knows it well in our place—than the "name of a pipe."[1] Now, what lends the figure its strangeness is not the "contradiction" between the image and the text. For a good reason: Contradiction could exist only between two statements, or within one and the same statement. Here there is clearly but one, and it cannot be contradictory because the subject of the proposition is a simple demonstrative. False, then, because its "referent"—obviously a pipe—does not verify it? But who would seriously contend that the collection of intersecting lines above the text *is* a pipe? Must we say: My God, how simpleminded! The statement is perfectly true, since it is quite apparent that the drawing representing the pipe is not the pipe itself. And yet there is a convention of language: What is this drawing? Why, it is a calf, a square, a flower. An old custom not without basis, because the entire function of so scholarly, so academic a drawing is to elicit

recognition, to allow the object it represents to appear without hesitation or equivocation. No matter that it is the material deposit, on a sheet of paper or a blackboard, of a little graphite or a thin dust of chalk. It does not "aim" like an arrow or a pointer toward a particular pipe in the distance or elsewhere. It *is* a pipe.

What misleads us is the inevitability of connecting the text to the drawing (as the demonstrative pronoun, the meaning of the word *pipe*, and the likeness of the image all invite us to do here)—and the impossibility of defining a perspective that would let us say that the assertion is true, false, or contradictory.

I cannot dismiss the notion that the sorcery here lies in an operation rendered invisible by the simplicity of its result, but which alone can explain the vague uneasiness provoked. The operation is a calligram[2] that Magritte has secretly constructed, then carefully unraveled. Each element of the figure, their reciprocal position and their relationship derive from this process, annulled as soon as it has been accomplished. Behind this drawing and these words, before anyone has written anything at all, before the formation of the picture (and within it the drawing of the pipe), before the large, floating pipe has appeared—we must assume, I believe, that a calligram has formed, then unraveled. There we have evidence of failure and its ironic remains.

In its millennial tradition, the calligram has a triple role: to augment the alphabet, to repeat something without the aid of rhetoric, to trap things in a double cipher. First it brings a text and a shape as close to-

gether as possible. It is composed of lines delimiting the form of an object while also arranging the sequence of letters. It lodges statements in the space of a shape, and makes the text *say* what the drawing *represents*. On the one hand, it alphabetizes the ideogram, populates it with discontinuous letters, and thus interrogates the silence of uninterrupted lines.[3] But on the other hand, it distributes writing in a space no longer possessing the neutrality, openness, and inert blankness of paper. It forces the ideogram to arrange itself according to the laws of a simultaneous form. For the blink of an eye, it reduces phoneticism to a mere grey noise completing the contours of the shape; but it renders outline as a thin skin that must be pierced in order to follow, word for word, the outpouring of its internal text.

The calligram is thus tautological. But in opposition to rhetoric. The latter toys with the fullness of language. It uses the possibility of repeating the same thing in different words, and profits from the extra richness of language that allows us to say different things with a single word. The essence of rhetoric is in allegory. The calligram uses that capacity of letters to signify both as linear elements that can be arranged in space and as signs that must unroll according to a unique chain of sound. As a sign, the letter permits us to fix words; as line, it lets us give shape to things. Thus the calligram aspires playfully to efface the oldest oppositions of our alphabetical civilization: to show and to name; to shape and to say; to reproduce and to articulate; to imitate and to signify; to look and to read.

Pursuing its quarry by two paths, the calligram sets the most perfect trap. By its double function, it guarantees capture, as neither discourse alone nor a pure drawing could do. It banishes the invincible absence that defeats words, imposing upon them, by the ruses of a writing at play in space, the visible form of their referent. Cleverly arranged on a sheet of paper, signs invoke the very thing of which they speak—from outside, by the margin they outline, by the emergence of their mass on the blank space of the page. And in return, visible form is excavated, furrowed by words that work at it from within, and which, dismissing the immobile, ambiguous, nameless presence, spin forth the web of significations that christen it, determine it, fix it in the universe of discourse. A double trap, unavoidable snare: How henceforth would escape the flight of birds, the transitory form of flowers, the falling rain?

And now Magritte's drawings. Let us begin with the first and simplest. It seems to be created from the fragments of an unraveled calligram. Under the guise of reverting to a previous arrangement, it recovers its three functions—but in order to pervert them, thereby disturbing all the traditional bonds of language and the image.

After having invaded the figure in order to reconstitute the old ideogram, the text has now resumed its place. It has returned to its natural site—below the image, where it serves to support it, name it, explain it, decompose it, insert it in the series of texts and in the pages of the book. Once more it becomes a "legend." Form itself reascends to the ethereal realm from which the complicity of letters with space had

forced it for an instant to descend. Free from all dis-
cursive attachment, it can float anew in its natural
silence. We return to the page, and to its old principle
of distribution—but only apparently. Because the
words we now can read underneath the drawing are
themselves drawn—images of words the painter has
set apart from the pipe, but within the general (yet
still undefinable) perimeter of the picture. I must read
them superimposed upon themselves. They are
words drawing words; at the surface of the image,
they form the reflection of a sentence saying that this
is not a pipe. The image of a text. But conversely, the
represented pipe is drawn by the same hand and with
the same pen as the letters of the text: it extends the
writing more than it illustrates it or fills its void. We
might imagine it brimming with small, chaotic let-
ters, graphic signs reduced to fragments and dispersed
over the entire surface of the image. A figure in the
shape of writing. The invisible, preliminary calli-
graphic operation intertwined the writing and the
drawing: and when Magritte restored things to their
own places, he took care that the shape would pre-
serve the patience of writing and that the text remain
always only a drawing of a representation.

The same for tautology. From calligraphic dou-
bling, Magritte seemingly returns to the simple corre-
spondence of the image with its legend. Without say-
ing anything, a mute and adequately recognizable
figure displays the object in its essence; from the im-
age, a name written below receives its "meaning" or
rule for usage. Now, compared to the traditional
function of the legend, Magritte's text is doubly pa-
radoxical. It sets out to name something that evi-

dently does not need to be named (the form is too well
known, the label too familiar). And at the moment
when he should reveal the name, Magritte does so by
denying that the object is what it is. Whence comes
this strange game, if not from the calligram? From the
calligram that says things twice (when once would
doubtless do); from the calligram that shuffles what it
says over what it shows to hide them from each other.
For the text to shape itself, for all its juxtaposed signs
to form a dove, a flower, or a rainstorm, the gaze
must refrain from any possible reading. Letters must
remain points, sentences lines, paragraphs surfaces or
masses—wings, stalks, or petals. The text must say
nothing to this gazing subject who is a viewer, not a
reader. As soon as he begins to read, in fact, shape
dissipates. All around the recognized word and the
comprehended sentence, the other graphisms take
flight, carrying with them the visible plenitude of
shape and leaving only the linear, successive unfurling
of meaning—not one drop of rain falling after an-
other, much less a feather or a torn-off leaf. Despite
appearances, in forming a bird, a flower, or rain, the
calligram does not say: These things *are* a dove, a
flower, a downpour. As soon as it begins to do so, to
speak and convey meaning, the bird has already
flown, the rain has evaporated. For whoever sees it,
the calligram *does not say*, *cannot yet say*: This is a
flower, this is a bird. It is still too much trapped
within shape, too much subject to representation by
resemblance, to formulate such a proposition. And
when we read it, the deciphered sentence ("this is a
dove," "this is a rainstorm") *is not* a bird, is no longer
a shower. By ruse or impotence, small matter—the

calligram never speaks and represents at the same moment. The very thing that is both seen and read is hushed in the vision, hidden in the reading.

Magritte redistributed the text and the image in space. Each regains its place, but not without keeping some of the evasiveness proper to the calligram. The drawn form of the pipe is so easily recognized that it excludes any explanatory or descriptive text. Its academic schematicism says very explicitly, "You see me so clearly that it would be ridiculous for me to arrange myself so as to write: This is a pipe. To be sure, words would draw me less adequately than I represent myself." And in this sketch representing handwriting, the text in turn prescribes: "Take me for what I manifestly am—letters placed beside one another, arranged and shaped so as to facilitate reading, assure recognition, and open themselves even to the most stammering schoolboy. I do not claim to swell, then stretch, becoming first the bowl, then the stem of the pipe. I am no more than the words you are now reading." Against one another in the calligram are pitted a "not yet to say" and a "no longer to represent." In Magritte's *Pipe*, the birthplace of these negations is wholly different from the point where they are applied. The "not yet to say" returns not exactly in an affirmation, but in a double position. On the one hand, overhead, the polished, silent, visible shape, on whose proud and disdainful evidence the text is allowed to say whatever it pleases. On the other hand, below, the text, displayed according to its intrinsic law, affirms its own autonomy in regard to what it names. The calligram's redundance rested on a relation of exclusion. In Magritte, the separation of the

two elements, the absence of letters in the drawing, the negation expressed in the text—all of these positively manifest two distinct positions.

But I have neglected, I fear, what is perhaps essential to Magritte's *Pipe*. I have proceeded as if the text said, "I (the ensemble of words you are now reading) am not a pipe." I have gone on as if there were two simultaneously and clearly differentiated positions within the same space: the figure's and the text's. But I have omitted that from one position to the other a subtle and instable dependency, at once insistent and unsure, is indicated. And it is indicated by the word "this." We must therefore admit between the figure and the text a whole series of intersections—or rather attacks launched by one against the other, arrows shot at the enemy target, enterprises of subversion and destruction, lance blows and wounds, a battle. For example, "this" (the drawing, whose form you doubtless recognize and whose calligraphic heritage I have just traced) "is not" (is not substantially bound to. . . , is not constituted by. . . , does not cover the same material as . . .) "a pipe" (that is, this word from your language, made up of pronounceable sounds that translate the letters you are reading). Therefore, *This is not a pipe* can be read thus:

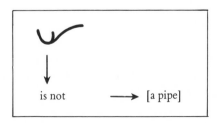

But at the same time, the text states an entirely different proposition: "This" (the statement arranging itself beneath your eyes in a line of discontinuous elements, of which *this* is both the signifier and the first word) "is not" (could neither equal nor substitute for. . . , could not adequately represent . . .) "a pipe" (one of the objects whose possible rendering can be seen above the text—interchangeable, anonymous, inaccessible to any name). Then we must read:

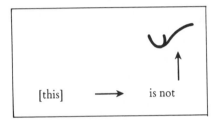

Now, on the whole it easily seems that Magritte's statement is negated by the immediate and reciprocal dependency between the drawing of the pipe and the text by which the pipe can be named. Designation and design do not overlap one another, save in the calligraphic play hovering in the ensemble's background and conjured away simultaneously by the text, the drawing, and their current separation. Hence the third function of the statement: "This" (this ensemble constituted by a written pipe and a drawn text) "is not" (is incompatible with) "a pipe" (this mixed element springing at once from discourse and the image, whose ambiguous being the verbal and visual play of the calligram wants to evoke).

Magritte reopened the trap the calligram had sprung on the thing it described. But in the act, the object itself escaped. On the page of an illustrated book, we seldom pay attention to the small space running above the words and below the drawings, forever serving them as a common frontier. It is there, on these few millimeters of white, the calm sand of the page, that are established all the relations of designation, nomination, description, classification. The calligram absorbed that interstice; but once opened, it does not restore it. The trap shattered on emptiness: image and text fall each to its own side, of their own weight. No longer do they have a common ground nor a place where they can meet, where words are capable of taking shape and images of entering into lexical order. The slender, colorless, neutral strip, which in Magritte's drawing separates the text and the figure, must be seen as a crevasse—an uncertain, foggy region now dividing the pipe floating in its imagistic heaven from the mundane tramp of words marching in their successive line. Still it is too much to claim that there is a blank or lacuna: instead, it is an absence of space, an effacement of the "common

place" between the signs of writing and the lines of the image. The "pipe" that was at one with both the statement naming it and the drawing representing it—this shadow pipe knitting the lineaments of form with the fiber of words—has utterly vanished. A disappearance that from the other side of this shallow stream[4] the text confirms with amusement: This is not a pipe. In vain the now solitary drawing imitates as closely as possible the shape ordinarily designated by the word *pipe*; in vain the text unfurls below the drawing with all the attentive fidelity of a label in a scholarly book. No longer can anything pass between them save the decree of divorce, the statement at once contesting the name of the drawing and the reference of the text.

Nowhere is there a pipe.

On this basis, we can understand Magritte's second version of *This Is Not a Pipe*. In placing the drawing of the pipe and the statement serving as its legend on the very clearly defined surface of a picture (insofar as it is a painting, the letters are but the image of letters; insofar as it is a blackboard, the figure is only the didactic continuation of a discourse), in placing the picture on a thick, solid wood tripod, Magritte does everything necessary to reconstruct (either by the permanence of a work of art or else by the truth of an object lesson) the space common to language and the image.

Everything is solidly anchored within a pedagogic space. A painting "shows" a drawing that "shows" the form of a pipe; a text written by a zealous instructor "shows" that a pipe is really what is meant. We do not see the teacher's pointer, but it rules

throughout—precisely like his voice, in the act of articulating very clearly, "This is a pipe." From painting to image, from image to text, from text to voice, a sort of imaginary pointer indicates, shows, fixes, locates, imposes a system of references, tries to stabilize a unique space. But why have we introduced the teacher's voice? Because scarcely has he stated, "This is a pipe," before he must correct himself and stutter, "This is not a pipe, but a drawing of a pipe," "This is not a pipe but a sentence saying that this is not a pipe," "The sentence 'this is not a pipe' is not a pipe," "In the sentence 'this is not a pipe,' *this* is not a pipe: the painting, written sentence, drawing of a pipe—all this is not a pipe."

Negations multiply themselves, the voice is confused and choked. The baffled master lowers his extended pointer, turns his back to the board, regards the uproarious students, and does not realize that they laugh so loudly because above the blackboard and his stammered denials, a vapor has just risen, little by little taking shape and now creating, precisely and without doubt, a pipe. "A pipe, a pipe," cry the students, stamping away while the teacher, his voice sinking ever lower, murmurs always with the same obstinacy though no one is listening, "And yet it is not a pipe." He is not mistaken; because the pipe floating so obviously overhead (like the object the blackboard drawing refers to, and in whose name the text can justifiably say that the drawing is truly not a pipe) is itself merely a drawing. It is *not* a pipe. No more on the board than above it, the drawing of the pipe and the text presumed to name it find nowhere

to meet and be superimposed, as the calligrapher so presumptuously had attempted to bring about.

So, on its beveled and clearly rickety mounts, the easel has but to tilt, the frame to loosen, the painting to tumble down, the words to be scattered. The "pipe" can "break": The common place[5]—banal work of art or everyday lesson—has disappeared.

3

Klee, Kandinsky, Magritte

Two principles, I believe, ruled Western painting from the fifteenth to the twentieth century. The first asserts the separation between plastic representation (which implies resemblance) and linguistic reference (which excludes it). By resemblance we demonstrate and speak across difference: The two systems can neither merge nor intersect. In one way or another, subordination is required. Either the text is ruled by the image (as in those paintings where a book, an inscription, a letter, or the name of a person are represented); or else the image is ruled by the text (as in books where a drawing completes, as if it were merely taking a short cut, the message that words are charged to represent). True, the subordination remains stable only very rarely. What happens to the text of the book is that it becomes merely a commentary on the image, and the linear channel, through words, of its simultaneous forms; and what happens to the picture is that it is dominated by a text, all of whose significations it figuratively illustrates. But no matter the meaning of the subordination or the manner in which it prolongs, multiplies, and reverses itself. What is essential is that

verbal signs and visual representations are never given at once. An order always hierarchizes them, running from the figure to discourse or from discourse to the figure.

This is the principle whose sovereignty Klee abolished, by showing the juxtaposition of shapes and the syntax of lines in an uncertain, reversible, floating space (simultaneously page and canvas, plane and volume, map and chronicle). Boats, houses, persons are at the same time recognizable figures and elements of writing. They are placed and travel upon roads or canals that are also lines to be read. Trees of the forest file over musical staves. The gaze encounters words as if they had strayed to the heart of things, words indicating the way to go and naming the landscape being crossed. And at the nexus of these figures and signs, the arrow that crops up so often (the arrow, sign bearing a primal resemblance, like a graphic onomatopoeia, and shape that formulates an order)—the arrow indicates the direction in which the boat is traveling, shows that the sun is setting, prescribes the direction that the gaze must follow, or rather the line along which it must imaginatively shift the figure provisionally and a bit arbitrarily placed here. It is not, in fact, a question of those calligrams that by turns bring into play the subordination of sign to form (a cloud of words and letters taking the shape they designate), then of form to sign (the figure dissecting itself into alphabetical elements). Nor is it any longer a question of those collages or reproductions that capture the cut out form of letters in fragments of objects; but rather a question of the intersection, within the same medium, of representation by resem-

blance and of representation by signs. Which presupposes that they meet in quite another space than that of the painting.

The second principle that long ruled painting posits an equivalence between the fact of resemblance and the affirmation of a representative bond. Let a figure resemble an object (or some other figure), and that alone is enough for there to slip into the pure play of the painting a statement—obvious, banal, repeated a thousand times yet almost always silent. (It is like an infinite murmur—haunting, enclosing the silence of figures, investing it, mastering it, extricating the silence from itself, and finally reversing it within the domain of things that can be named.) "What you see is *that*." No matter, again, in what sense the representative relation is posed—whether the painting is referred to the visible world around it, or whether it independently establishes an invisible world that resembles itself.

The essential point is that resemblance and affirmation cannot be dissociated. The rupture of this principle can be ascribed to Kandinsky: a double effacement simultaneously of resemblance and of the representative bond, by the increasingly insistent affirmation of the lines, the colors that Kandinsky called "things," neither more nor less objects than the church, the bridge, or the knight with his bow. Kandinsky's is a naked affirmation clutching at no resemblance, and which, when asked "what it is," can reply only by referring itself to the gesture that formed it: an "improvisation," a "composition"; or to what is found there: "a red shape," "triangles," "purple orange"; or to tensions or internal relations: "a deter-

minant pink," "upwards," "a yellow milieu," "a rosy balance." No one, apparently, is further from Klee and Kandinsky than Magritte. More than any other, his painting seems wedded to exact resemblances, to the point where they willfully multiply as if to assert themselves. It is not enough that the drawing of the pipe so closely resembles a pipe. Nor is it enough that the tree so closely resembles the tree, and the leaf the leaf. Rather the leaf of the tree will take on the shape of the tree itself, and the latter will take the form of the leaf (*L'Incendie*[1]). The ship at sea will not resemble merely a ship, but also the sea itself, even to its hull and sails being composed of waves (*Le Séducteur*[2]). And the exact representation of a pair of shoes moreover will try to resemble the bare feet the shoes ought to cover.[3]

An art more committed than any other to the careful and cruel separation of graphic and plastic elements. If they happen to be superimposed within the painting like a legend and its image, it is on condition that the statement contest the obvious identity of the figure, and the name we are prepared to give it. Something exactly like an egg is called *l'acacia*—a shoe *la lune*, a bowler hat *la niege*, a candle *la plafond*.[4] And yet Magritte's art is not foreign to the enterprise of Klee and Kandinsky. Rather it constitutes, facing them and on the basis of a system common to them all, a figure at once opposed and complementary.

4

Burrowing Words

The exteriority of written and figurative elements, so obvious in Magritte, is symbolized by the non-relation—or in any case by the very complex and problematic relation—between the painting and its title. This gulf, which prevents us from being both the reader and the viewer at the same time, brings the image into abrupt relief above the horizontal line of words. "The titles are chosen in such a way as to keep anyone from assigning my paintings to the familiar region that habitual thought appeals to in order to escape perplexity." A little like the anonymous hand that designated the pipe by the statement, "This is not a pipe," Magritte names his paintings in order to focus attention upon the very act of naming. And yet in this split and drifting space, strange bonds are knit, there occur intrusions, brusque and destructive invasions, avalanches of images into the milieu of words, and verbal lightning flashes that streak and shatter the drawings. Patiently, Klee constructed a space without name or geometry, tangling the chain of signs with

TRANSLATOR'S NOTE: The original title of this chapter is "Le Sourd travail des mots," literally, "The Subterranean Work of Words." The connotation is of weakening or subversion through undercutting.

the fiber of figures. Magritte secretly mines a space he seems to maintain in the old arrangement. But he excavates it with words: And the old pyramid of perspective is no more than a molehill about to cave in.

In any reasonable drawing, a subscript such as "This is not a pipe" is enough immediately to divorce the figure from itself, to isolate it from its space, and to set it floating—whether near or apart from itself, whether similar to or unlike itself, no one knows. Against *Ceci n'est pas une pipe*, there is *L'Art de la conversation*:[1] In a landscape of battling giants or of the beginning of the world, two tiny persons are speaking—an inaudible discourse, a murmur instantly reabsorbed into the silence of the stones, into the silence of a wall whose enormous blocks overhang the two garrulous mutes. Jumbled together, the blocks form at their base a group of letters where it is easy to make out the word: REVE[2] (which can, if we look a bit more closely, be completed as TREVE[3] or CREVE[4])—as if all these airy, fragile words had been given the power to organize the chaos of stones. Or as if, on the contrary, behind the alert but immediately lost chatter of men, things could in their silence and sleep compose a word—a permanent word no one could efface; yet this word now designates the most fleeting of images. But this is not all: Because it is in dream that men, at last reduced to silence, commune with the signification of things and allow themselves to be touched by enigmatic, insistent words that come from elsewhere. *Ceci n'est pas une pipe* exemplifies the penetration of discourse into the form of things; it reveals discourse's ambiguous power to deny and to redouble. *L'Art de la conversation* marks

the anonymous attraction of things that form their own words in the face of men's indifference, insinuating themselves, without men even being aware of it, into their daily chatter.

Between the two extremes, Magritte's work deploys the play of words and images. Often invented after the fact and by other people, the titles intrude into the figures where their applicability was if not indicated at least authorized in advance, and where they play an ambiguous role: supporting pegs and yet termites that gnaw and weaken. The countenance of an absolutely serious man, unsmiling, unblinking, "breaks up" with a laughter that comes from nowhere.[5] *Le Soir qui tombe*[6] cannot fall without shattering a windowpane whose fragments (still retaining, on their sharp edges and glass shards, the sun's reflections) are scattered on the floor and sill. Referring to the sun's disappearance as a "fall," the words have swept along, with the image they evoke, not only the windowpane but the other sun, the twin sun perfectly outlined on the smooth and transparent glass. Like a clapper in a bell, the key stands vertically "in the keyhole": it rings forth the familiar expression[7] until it becomes absurd.

Moreover, listen to Magritte: "Between words and objects one can create new relations and specify characteristics of language and objects generally ignored in everyday life." Or again: "Sometimes the name of an object takes the place of an image. A word can take the place of an object in reality. An image can take the place of a word in a proposition." And the following statement, conveying no contradiction but referring to the inextricable tangle of words and images and to

the absence of a common ground to sustain them: "In a painting, words are of the same cloth as images. Rather one sees images and words differently in a painting."*

Of these substitutions, these transubstantiations, there are many examples in Magritte's work. In *Personnage marchant vers l'horizon*,[8] there is the famous fellow seen from behind, with dark hat and coat, hands in his pockets. He is situated near five colored blobs. Three of them rest on the ground and bear the italicized words *fusil*, *fauteuil*, *cheval*; another, overhead, is called *nuage*; finally, at the terminus of earth and sky, another vaguely triangular blob is called *horizon*.[9] We are a long way from Klee and his *regard-lecture*.[10] This is by no means a matter of weaving signs and spatial figures into a unique and absolutely novel form. Words are not bound directly to other pictorial elements. They are merely inscriptions on blobs and shapes: Their distribution above and below, right and left, is true to the traditional layout of the painting. The horizon is indeed in the background, the cloud overhead, the sun situated vertically and to the left. But within this familiar context, words do not replace missing objects. They occupy no empty or hollow spaces, because the inscription-bearing blobs are thick, voluminous masses, stones or menhirs whose shadows stretch forth on the ground beside that of the man. These "word-bearers" are thicker, more substantial than the objects themselves. They are barely-formed things (a vague triangle for

*AUTHOR'S NOTE: I cite all these quotations from P. Waldberg's *Magritte*. They illustrated a series of drawings in the twelfth issue of *Revolution surrealiste*.

the horizon, a rectangle for the horse, a perpendicular
for the gun) with neither shape nor identity. The sort
of things that cannot be named and that in fact
"name" themselves bear an exact and familiar name.
The painting is the converse of a rebus, that chain of
shapes so easily recognized as to be immediately
identifiable, its mere formulation enjoining the articu-
lation of a sentence whose meaning has nothing to do
with the figures actually seen there. Here, shapes are
so vague as to be unnameable if they did not identify
themselves. And on the real painting as seen—blobs,
shadows, silhouettes—there is superimposed the in-
visible possibility of another painting at once familiar
because of the figures presented and yet bizarre be-
cause of the juxtaposition of horse and armchair. An
object in a painting is a volume organized and tinted
so that its shape is immediately recognizable and need
not be named. In form, the indispensable mass is ab-
sorbed, the useless name dismissed. Magritte elides
the object's form and superimposes the name directly
upon the mass. The substantive link of the object itself
is no longer represented except by its two extreme
points, the mass that casts a shadow and the name that
designates it.

L'Alphabet des révélations[11] contrasts rather precisely
with *Personnage marchant vers l'horizon*: a great wood-
en frame divided into panels; on the right, some sim-
ple, perfectly recognizable forms: a pipe, a key, a leaf,
a glass. At the bottom of the right panel, the
configuration of a rip shows that the shapes are no
more than cut outs in a sheet of thin paper. On the
other panel, a kind of twisted, tangled string depicts
no recognizable shape (save perhaps, and this is very

doubtful: LA, LE[12]). No mass, no name, form without volume, an empty cut out, this is the object—the object that had vanished from the preceding painting.

Make no mistake: In a space where every element seems to obey the sole principle of resemblance and plastic representation, linguistic signs (which had an excluded aura, which prowled far around the image, which the title's arbitrariness seemed to have banished forever) have surreptitiously reapproached. Into the solidity of the image, into its meticulous resemblance, they have introduced a disorder—an order pertaining to the eyes alone. They have routed the object, revealing its filmy thinness.

In order to deploy his plastic signs, Klee wove a new space. Magritte allows the old space of representation to rule, but only at the surface, no more than a polished stone, bearing words and shapes: beneath, nothing. It is a gravestone: The incisions that drew figures and those that marked letters communicate only by void, the non-place hidden beneath marble solidity. I will note that this absence reascends to the surface and impinges upon the painting itself. When Magritte offers his version of *Madame Récamier* or *Le Balcon*,[13] he replaces the traditional paintings' characters with coffins. Invisibly contained between waxen oak planks, emptiness undoes the space composed by the volume of living bodies, the arrangement of clothing, the direction of the gaze and all the faces that are about to speak. The "non-place" emerges "in person"—in place of persons and where no one is present any longer.[14]

And when the word assumes the solidity of an object, I think about that corner of the floor on which is

written, in white paint, the word *"sirene"*—written
with a huge upraised finger, piercing the floor verti-
cally at the *i* and directed toward the small bell that
serves to dot it. Word and object do not tend to con-
stitute a single figure; on the contrary they are de-
ployed in two different dimensions. The finger that
traverses the script rises above it, imitating and ob-
scuring the *i;* the finger that represents the word's
pointing function and takes somewhat the shape of
those towers upon which sirens were placed—the
finger points only toward the ubiquitous bell.[15]

5

Seven Seals of Affirmation

With a sovereign and unique gesture, Kandinsky dismissed the old equivalence between resemblance and affirmation, freeing painting from both. Magritte proceeds by dissociating the two: disrupting their bonds, establishing their inequality, bringing one into play without the other, maintaining that which stems from painting, and excluding that which is closest to discourse—pursuing as closely as possible the indefinite continuation of the similar, but excising from it any affirmation that would attempt to say what is resembled. An art of the "Same," liberated from the "as if." We are farthest from *trompe-l'œil*.[1] The latter seeks to support the weightiest burden of affirmation by the ruse of a convincing resemblance: "What you see on the wall's surface is not an aggregate of lines and colors. It is depth, sky, clouds that have shaded your house, a real column around which you could walk, a stairway that continues the steps you have begun to climb (already you start toward it, despite yourself), a stone balustrade over which lean the attentive faces of ladies and courtiers, wearing clothes identical to your own, to the very ribbons, smiling at your astonishment and your own smiles, gesturing to you in a fashion that is mysterious

because they have answered you without even
waiting for your own gestures to them."

To me it appears that Magritte dissociated simili-
tude from resemblance, and brought the former into
play against the latter. Resemblance has a "model," an
original[2] element that orders and hierarchizes the in-
creasingly less faithful copies that can be struck from
it. Resemblance presupposes a primary reference that
prescribes and classes. The similar develops in series
that have neither beginning nor end, that can be fol-
lowed in one direction as easily as in another, that
obey no hierarchy, but propagate themselves from
small differences among small differences. Resem-
blance serves representation, which rules over it; si-
militude serves repetition, which ranges across it.
Resemblance predicates itself upon a model it must
return to and reveal; similitude circulates the simu-
lacrum as an indefinite and reversible relation of the
similar to the similar.

Take *Représentation* (1962): an exact representation
of a portion of a ball game, seen from a kind of terrace
fenced by a low wall. On the left, the wall is topped
by a balustrade, and in the juncture thus formed can
be seen exactly the same scene, but on a smaller scale
(about one-half). Must we suppose, unfolding on the
left, a series of smaller and smaller other "repre-
sentations," always identical? Perhaps. But it is un-
necessary. In the same painting, two images bound
thus laterally by a relation of similitude are enough for
exterior reference to a model—through resem-
blance—to be disturbed, rendered floating and uncer-
tain. What "represents" what? Even as the exactness

of the image functioned as a finger pointing to a model, to a sovereign, unique, and exterior "pattern," the series of similitudes (and two are enough to establish a series) abolishes this simultaneously real and ideal monarchy. Henceforth the simulacrum, in a sense always reversible, ranges across the surface.

In *Décalcomanie* (1966):[3] Occupying two thirds of the painting, a red curtain with large pleats obscures a landscape of sky, sea, and sand. Beside the curtain, turning his back as usual to the viewer, the man with the bowler hat looks out to sea.

Now, we find that the curtain has been cut out in exactly the shape of the man: as if he himself (although of another color, texture, and width) were merely a section of curtain snipped away by scissors. Within the large opening the beach is visible. What are we to make of this? Is it that the man, in changing places, having departed the curtain, exposes what he was looking at when he was still enfolded within it? Or is it that the painter, in moving the man a few centimeters, has set against the curtain that fragment of sky, water, and sand that the man's silhouette hid from the viewer—so that thanks to the cooperation of the artist, we can see what is contemplated by the silhouette that blocks our view? Or must we admit that at the moment the man turns to look at it, the fragment of landscape immediately before him has leapt aside, avoiding his gaze so that before his eyes it became his shadow, the black smudge of his body? Transference? Doubtless. But from what to what? From where to where? The thick black silhouette of the man seems to have been shifted from right to left,

from the curtain onto the landscape he now obscures; the fold he makes in the curtain displays his prior position. But in the shape of a man's silhouette, the landscape has also been cut loose and transferred from left to right. The scrap of red curtain that remains bizarrely attached to the shoulder of this human landscape, and that corresponds to the small part of curtain hidden by the black silhouette, in itself demonstrates the origin and the location from which the sky and water were cut. A displacement and exchange of similar elements, but by no means mimetic reproduction.

And thanks to *Décalcomanie* the advantage of similitude over resemblance can be grasped. The latter reveals the clearly visible; similitude reveals what recognizable objects, familiar silhouettes hide, prevent from being seen, render invisible. ("Body" = "curtain," says mimetic representation. "Right is left, left is right; the hidden here is visible there; the sunken is in relief; flatness extends into depth," say the similitudes of *Décalcomanie*.) Resemblance makes a unique assertion, always the same: This thing, that thing, yet another thing is something else. Similitude multiplies different affirmations, which dance together, tilting and tumbling over one another.

Hounded from the space of the painting, excluded from the relation between things that refer to one another, resemblance vanishes. But is it not in order to reign elsewhere, freed from the indefinite play of similitude? Is it not the role of resemblance to be the sovereign that makes things appear? Is not resemblance, a property of objects, also the property of thought as well? "Only thought," says Magritte, "can

resemble. It resembles by being what it sees, hears, or knows; it becomes what the world offers it."
Thought resembles without similitude, becoming those things whose mutual similitude excludes resemblance. Magritte's painting doubtless rests here, where thought in the mode of resemblance and things in relations of similitude have just vertically intersected.*

Let us reconsider the drawing of a pipe that bears so strong a resemblance to a real pipe; the written text that bears so strong a resemblance to the drawing of a written text. In fact, whether conflicting or just juxtaposed, these elements annul the intrinsic resemblance they seem to bear within themselves, and gradually sketch an open network of similitudes. Open—not onto the "real" pipe, absent from all these words and drawings,[4] but onto all the other similar elements (including all "real" pipes of clay, meerschaum, wood, etc.) that, once drawn into the network, would take the place and function of the simulacrum. Each element of "this is not a pipe" could hold an apparently negative discourse—because it denies, along with resemblance, the assertion of reality resemblance conveys—but one that is basically affirmative: the affirmation of the simulacrum, affirmation of the element within the network of the similar.

Let us establish the series of these affirmations, which reject the assertion of resemblance and are found concentrated in the proposition: This is not a pipe. To do so it is sufficient to pose the question:

*AUTHOR'S NOTE: The reader should examine René Passeron's *René Magritte,* particularly the last chapter.

Who speaks in the statement? Or rather it suffices to interrogate in turn the elements deployed by Magritte; because at bottom all of them can say either of themselves or of their neighbors: This is not a pipe.

First the pipe itself: "What you see here, the lines I form or that form me, is not a pipe as you doubtless believe; but a drawing in a relation of vertical similitude to the other pipe (real or not, true or false, I do not know) that you see over there—just above the painting where I am, a simple and solitary similitude." To which the higher pipe responds in the same words: "What you see floating before your eyes, beyond space and without fixed foundation, this mist that settles neither on canvas nor on a page, how could it really be a pipe? Don't be misled: I am mere similarity—not something similar to a pipe, but the cloudy similitude that, referring to nothing, traverses and brings together texts such as the one you can read and drawings such as the one below." But the statement, already articulated twice by different voices, in turn comes forward to speak for itself. "The letters that form me and that you see—the moment you try to read them as naming the pipe, how can they say that they are a pipe, these things so divorced from what they name? This is a graphism that resembles only itself, and that could never replace what it describes."

But there is more. Two by two the voices mingle to say a third element is not a pipe. Bound together by the frame of the painting enclosing them, the text and the lower pipe enter into complicity: The designating power of words and the illustrative power of drawing denounce the higher pipe, and refuse the abstract ap-

parition the right to call itself a pipe, because its un-
anchored existence renders it mute and invisible.
Bound together by their reciprocal similitude, the
two pipes contest the written statement's right to call
itself a pipe, for it is composed of signs with no resem-
blance to the thing they designate. Bound together by
the fact that they each come from elsewhere, that one
is a discourse capable of conveying truth while the
other is like the ghost of a thing-in-itself, the text and
the higher pipe join to assert that the pipe in the paint-
ing is not a pipe. And perhaps we must also assume
that from beyond these three alliances, a dislocated
voice (that of the painting or the blackboard, possi-
bly) speaks of both the pipe in the painting and the one
above it: "None of these is a pipe, but rather a text that
simulates a pipe; a drawing of a pipe that simulates a
drawing of a pipe; a pipe (drawn other than as a draw-
ing) that is the simulacrum of a pipe (drawn after a
pipe that itself would be other than a drawing)."
Seven discourses in a single statement—more than
enough to demolish the fortress where similitude was
held prisoner to the assertion of resemblance.

Henceforth similitude is restored to itself—
unfolding from itself and folding back upon itself. It
is no longer the finger pointing out from the canvas in
order to refer to something else. It inaugurates a play
of transferences that run, proliferate, propagate, and
correspond within the layout of the painting,
affirming and representing nothing. Thus in Ma-
gritte's art we find infinite games of purified simili-
tude that never overflow the painting. They establish
metamorphoses: but in what sense? Is it the plant
whose leaves take flight and become birds, or the

birds that drown and slowly botanize themselves,
sinking into the ground with a final quiver of green-
ery (*Les Grâces naturelles*, *La Saveur des larmes*[5])? Is it
a woman who "takes to the bottle" or the bottle that
feminizes itself by becoming a "nude study"[6] (here
composing a disturbance of plastic elements because
of the latent insertion of verbal signs and the play of
an analogy that, affirming nothing, is doubly acti-
vated by the playfulness of the statement)? Instead of
blending identities, it happens that similitude also has
the power to destroy them: a woman's torso is sec-
tioned into three parts (increasingly larger as we move
from top to bottom). While holding back all
affirmation of identity, the shared proportions guar-
antee analogy: three segments lacking a fourth in just
the same fashion, though the fourth element is incal-
culable. The head (final element = x) is missing: *Folie
des grandeurs*,[7] says the title.

Another way similitude is freed from its old com-
plicity with representative affirmation: perfidiously
mixing (and by a ruse that seems to indicate just the
opposite of what it means) the painting and what it
represents. Evidently this is a way of affirming that
the painting is indeed its own model. But in fact such
an affirmation would imply an interior distance, a
divergence, a disjuncture between the canvas and
what it is supposed to mimic. For Magritte, on the
contrary, there exists from the painting to the model
a perfect continuity of scene, a linearity, a continuous
overflowing of one into the other. Either by gliding
from left to right (as in *La Condition humaine*, where
the sea's horizon follows the horizon on the canvas
without a break); or by the inversion of distances (as

in *La Cascade*,[8] where the model invades the canvas, envelops it on all sides, and gives it the appearance of being behind what ought to be on its far side). Opposed to this analogy that denies representation by erasing duality and distance, there is the contrary one that evades or mocks it by means of the snare of doubling. In *Le Soir qui tombe*, the windowpane bears a red sun analogous to the one hung in the sky (against Descartes and the way in which he resolved the two suns of appearance within the unity of representation). This is the converse of *La Lunette d'approche*:[9] through the transparence of a window can be seen the passing of clouds and the sparkle of a blue sea; but the window opens onto black void, showing this to be a reflection of nothing.

In *Les Liaisons dangereuses*,[10] a nude woman holds before her a mirror that almost completely hides her. She has her eyes nearly shut, she lowers and turns her head to the left, as if she did not want to be seen and to see that she is seen. Now the mirror, which is in the same plane as the painting and facing the viewer, reflects the image of the same woman who is trying to hide. The mirror's reflecting face shows the segment of her body (from shoulders to thighs) that the blind face conceals. The mirror functions a little like a fluoroscope, but with a whole play of differences. The woman is seen in profile, turned to the right, body bent slightly forward, arm not outstretched to hold the heavy mirror but rather tucked beneath her breasts. The long hair that ought to extend behind the mirror on the right streams down, in the mirror image, on the left, slightly interrupted by the frame at the point of the acute angle. The image is noticeably

smaller than the woman herself, indicating a certain distance between the glass and the reflected object that contests or is contested by the posture of the woman who presses the mirror against her body the better to hide. The small gap behind the mirror is shown again by the extreme proximity of a large grey wall. On it can be clearly seen the shadows cast by the woman's head and thighs and by the mirror. From the shadow one part is missing—that of the left hand that holds the mirror. Normally it should be seen on the right of the painting; here it is missing, as if in the shadow the mirror was supported by no one.

Behind the wall and the mirror, the hidden body is elided; in the thin space separating the mirror's polished, reflection-capturing surface and the opaque surface of the wall that catches only shadows, there is nothing. Through all these scenes glide similitudes that no reference point can situate: translations with neither point of departure nor support.

6

Nonaffirmative Painting

Separation between linguistic signs and plastic elements; equivalence of resemblance and affirmation. These two principles constituted the tension in classical painting, because the second reintroduced discourse (affirmation exists only where there is speech) into an art from which the linguistic element was rigorously excluded. Hence the fact that classical painting spoke—and spoke constantly—while constituting itself entirely outside language; hence the fact that it rested silently in a discursive space; hence the fact that it provided, beneath itself, a kind of common ground where it could restore the bonds of signs and the image.

Magritte knits verbal signs and plastic elements together, but without referring them to a prior isotopism. He skirts the base of affirmative discourse on which resemblance calmly reposes, and he brings pure similitudes and nonaffirmative verbal statements into play within the instability of a disoriented vol-

TRANSLATOR'S NOTE: The original title of this chapter is "Peindre n'est pas affirmer," literally, "To Paint Is Not to Affirm."

ume and an unmapped space. A process whose formulation is in some sense given by *Ceci n'est pas une pipe*.

1. To employ a calligram where are found, simultaneously present and visible, image, text, resemblance, affirmation, and their common ground.

2. Then suddenly to open it up, so that the calligram immediately decomposes and disappears, leaving as a trace only its own absence.

3. To allow discourse to collapse of its own weight and to acquire the visible shape of letters. Letters which, insofar as they are drawn, enter into an uncertain, indefinite relation, confused with the drawing itself—but minus any area to serve as a common ground.

4. To allow similitudes, on the other hand, to multiply of themselves, to be born from their own vapor and to rise endlessly into an ether where they refer to nothing more than themselves.

5. To verify clearly, at the end of the operation, that the precipitate has changed color, that it has gone from black to white, that the "This is a pipe" silently hidden in mimetic representation has become the "This is not a pipe" of circulating similitudes.

A day will come when, by means of similitude relayed indefinitely along the length of a series, the image itself, along with the name it bears, will lose its identity. Campbell, Campbell, Campbell, Campbell.[1]

Two Letters by René Magritte

To Michel Foucault

May 23, 1966

Dear Sir,

It will interest you, I hope, to consider these few reflections relative to my reading of your book *Les Mots et les choses*. . .

The words Resemblance and Similitude permit you forcefully to suggest the presence—utterly foreign—of the world and ourselves. Yet, I believe these two words are scarcely ever differentiated, dictionaries are hardly enlightening as to what distinguishes them.

It seems to me that, for example, green peas have between them relations of similitude, at once visible (their color, form, size) and invisible (their nature, taste, weight). It is the same for the false and the real, etc. Things do not have resemblances, they do or do not have similitudes.

Only thought resembles. It resembles by being what it sees, hears, or knows; it becomes what the world offers it.

It is as completely invisible as pleasure or pain. But painting interposes a problem: There is the thought that sees and can be visibly described. *Las Meninas* is the visible image of Velásquez's invisible thought.[1] Then is the invisible sometimes visible? On condition that thought be constituted exclusively of visible images.

On this topic, it is evident that a painted image—intangible by its very nature—hides nothing, while the tangibly visible object hides another visible thing—if we trust our experience.

For a time a curious priority has been accorded "the invisible," owing to a confused literature, whose interest vanishes if we remember that the visible can be hidden, but the invisible hides nothing; it can be known or not known, no more. There is no reason to accord more importance to the invisible than to the visible, nor vice versa.

What does not "lack" importance is the mystery evoked *in fact* by the visible and the invisible, and which can be evoked *in principle* by the thought that unites "things" in an order that evokes mystery.

Permit me to bring to your attention the enclosed reproductions

of paintings, which I executed without looking into the original purposes of their painters.

Sincerely yours,

René Magritte

June 4, 1966

Dear Sir,

Why did I see coffins where Manet saw pale figures? Your question regarding my painting *Perspective: Le Balcon de Manet* implies its own answer: The image my painting reveals where the decor of the "Balcony" is suitable for placing coffins.

The "mechanism" at work here could serve as the object of a scholarly explanation of which I am incapable. The explanation would be valuable, even irrefutable, but the mystery would remain undiminished.

The first painting called "Perspective" was a coffin situated on a stone in a landscape.

The "Balcony" is a variation on it; before, there were other versions: *Perspective: Madame Récamier, de David* and *Perspective: Madame Récamier, de Gerard*. A variation with, for example, the setting and characters of *L'Enterrement d'Ornans*[2] would heighten the parody.

I believe it should be pointed out that the paintings named Perspectives have a connotation distinct from the two ordinary meanings of the word. This word and others have a precise meaning in a context, but the context—you show it better than anyone else in *Les Mots et les choses*—can say nothing is confused, save the mind that imagines an imaginary world.

I am pleased that you recognize a resemblance between Roussel and whatever is worthwhile in my own thought. What he imagines evokes nothing imaginary, it evokes the reality of the world that experience and reason treat in a confused manner.

I hope to have the opportunity of meeting you during the exhibit I will have near Paris, at Iolas, toward the end of the year.

Sincerely yours,

René Magritte

Notes

Translator's Introduction

1. "Comte de Lautréamont" was the pseudonym of Isidore Ducasse (1846–70), whose long prose poem *Les Chants de Maldoror* inspired many important Surrealists. In 1938 Magritte contributed an illustration called *Le Viol* ("the rape") to an edition of the poem edited by André Breton. Ten years later he did all the illustrations (seventy-seven of them) for another edition issued in Brussels.

2. The length of *Ceci n'est pas une pipe* makes this introduction the wrong place to treat the details of Magritte's life and career more than briefly. For further information, the best English source is *Magritte* by Suzi Gablik (Greenwich, Conn.: New York Graphic Society, 1971). Harry M. Torczyner's *Magritte: Ideas and Images* (New York: Abrams, 1977) is an excellent anthology of both plates and primary documents (letters, etc.) for the serious Magritte scholar.

3. Bernard Noel, *Magritte* (New York: Crown Publications, Inc.), p. 79.

4. Michel Foucault, *The Order of Things*, a translation of *Les Mots et les choses* (New York: Pantheon, 1970), p. 48.

5. *Ibid.*, pp. 36–37.

6. *Ibid.*, p. 9.

7. Two difficulties arise here. One stems from Magritte's own highly idiosyncratic use of the term *resemblant*, "resembling." While the painter saw the difficulty and expressed certain reservations (see the first letter to Foucault), he clearly understood and endorsed the distinction Foucault was drawing. The other confusion arises from the word *similitude*. It might best be translated as "likeness," "similarity," or perhaps "a-likeness." Unfortunately, in *The Order of Things*—a work whose relation to *Ceci n'est pas une pipe* is quite intimate—similitude has been transposed unchanged. I am not fond of *similitude* = "similitude," but for the sake of consistency I have gone along.

8. In *The History of Sexuality, Volume I*, for example, Robert Hurley's translation entirely omits the multiple resonances and references to *Alice in Wonderland*.

1. Two Pipes

1. *Leçon de choses*, literally "lesson of things." An allusion to the title of a 1947 Magritte canvas, as well as a 1960 film about Magritte made by Luc de Heusch. Magritte also wrote an essay to which he gave the title.

2. "Dawn at the Ends of the Earth," the title of a book with illustrations by Magritte. Actually, Magritte's pipe and its wry subscript appear in a whole series of paintings and drawings. There is also a pun on the word *aube,* which can mean either "dawn" or "float."

3. "The Wrestlers' Tomb."

4. "The Battle of the Argonne."

2. The Unraveled Calligram

1. An untranslatable pun. Le *"nom d'une pipe"* is a mild or euphemistic oath on the order of "for Pete's sake" when substituted for "for God's sake." In the preceding remark, Foucault's point is that the slang expression has entered speech so integrally as to become idiomatic, with speakers using it without consciously attending its literal meaning.

2. A poem whose words are arranged in such fashion as to form a picture of its "topic," the calligram is associated closely with Apollinaire—who was, in fact, one of Magritte's favorite writers. In *The Shock of the New,* Robert Hughes speculates that Magritte's pipe was painted as a "riposte" to Le Corbusier, who had in 1923 held up the image of a pipe as an image of pure functionalism. Foucault also treats Magritte's canvas as a riposte, but aimed at an entirely different target (see Plate 7—"Fumées," by Apollinaire). Perhaps the most paradoxical riposte imaginable is the recent cover drawing of the avant-garde journal *Tel Quel:* there, the tiny letters composing a calligraphic depiction of a bull turn out, on closer inspection, to be Chinese ideograms—"picture-words" whose calligraphic shape in turn denotes a purely linguistic vulgarism.

3. Literally, "makes speak the silence of uninterrupted lines."

4. I am indebted to Dr. Sally Lawall for pointing out that in Mallarmé's poem on Verlaine, *ce peu profond ruisseau* ("this shallow stream") is an image of death. See "Tombeau," the funeral

sonnet for Paul Verlaine, in *Œuvres complètes de Stéphane Mallarmé*, ed. Henri Mondor et G. Jean-Aubry (Paris: Gallimard [Éditions de la Pléiade], 1956).

5. A complex pun that works oddly well in English. *Lieu commun*, "common place," signifies the common ground or shared conceptual site of language and drawing, visual and verbal representation; it also signifies the *commonplace*, that is, the ordinary. Foucault's point is that by effacing the former, Magritte also undermines the latter, enabling him to use quotidian objects to evoke mystery.

3. Klee, Kandinsky, Magritte

1. "The Conflagration."
2. "The Seducer."
3. Foucault is referring to *La Philosophie dans le boudoir*, "Philosophy in the Bedroom," and similar variations. See illustration.
4. In order, "acacia," "moon," "snow," and "ceiling."

4. Burrowing Words

1. "The Art of Conversation."
2. "Dream."
3. "Peace."
4. "Death."
5. Foucault refers to a sketch that illustrated the French edition of *Ceci n'est pas une pipe*. In it, a man's face is splintering, while on a rock at the left is inscribed, *homme éclatant avec rire*, "man breaking up with laughter." The visual pun is on the phrase "breaking up," which in French as well as English is slang for an abrupt seizure with merriment.
6. "The evening that falls," or "night fall."
7. That is, the expression by which evening's arrival is designated a "fall."
8. "Person walking toward the horizon."
9. In order, "gun," "armchair," "horse," "cloud," and "horizon."
10. Literally, "reading-gaze." The neologism remains less confusing in French than in English.

11. "The Alphabet of Revelations."

12. LA and LE could represent the feminine and masculine forms of "the."

13. "The Balcony." A Magritte painting reinterpreting a famous work by Manet. See Magritte's second letter to Foucault.

14. Foucault seems to be contrasting the "non-place" of mystery with the "commonplace" of ordinariness. See Chapter II, note 5, as well as Foucault's reference to "the non-place of language" in the preface to *Les Mots et les choses*, p. xvii.

15. In various sizes, a round bell of the sort Americans call a "jingle bell" is a frequently encountered figure in Magritte's work.

5. Seven Seals of Affirmation

1. Regarding *trompe-l'œil*, Magritte wrote in 1946: ". . . if the images are precise, in formal terms, the more precise they are, the more perfect the *trompe-l'œil*, THE GREATER THE DECEPTION . . ." In 1963 he added, "*Trompe-l'œil* (if indeed there is such a thing) does not belong to the realm of painting. It is rather a 'playful physics'?"

2. "Original" in its most transitive sense, that is, not only "first" but also "generative."

3. "Decalcomania." The title embodies a complex play of ideas. *Décalcomanie* means transference, transferency, or decal; it is also a painterly technique (often mentioned by Breton) in which pigment is transferred from one side of a painted surface to another by folding over the canvas. Finally, *décalcomanie* refers to a species of madness bound up with the idea of shifting identities.

4. Another echo of Mallarmé: Flowers "absent from all bouquets" are mentioned in the essay "*Crise de vers*" and in Mallarmé's preface to René Ghil's "*Traite du Verbe.*" Both are included in the Pleiade edition of *Œuvres complètes*.

5. "The Natural Graces," "The Flavor of Tears."

6. A bizarre pun. Literally *corps nu*, "naked body." Spoken aloud, the phrase sounds like *cornu*, "horned"—slang for cuckoldry, or more generally any sexual betrayal.

7. "Delusions of Grandeur."

8. "The Waterfall."

9. "The Field Glass."
10. "Dangerous Liaisons."

6. Nonaffirmative Painting

1. Foucault's reference is not to Magritte but to Andy Warhol, whose various series of soup cans, celebrity portraits, and so on Foucault apparently sees as undermining any sense of the unique, indivisible identity of their "models." See Foucault's comments on Warhol in the important essay "Theatricum Philosophicum," reprinted in *Language, Counter Memory, Practice* (Ithaca, New York: Cornell University Press, 1977).

Two Letters by René Magritte

1. *Las Meninas*, "the servants," was the frontispiece for *Les Mots et les choses* and the topic of its first chapter.
2. "Burial at Ornans."

Index

Plates

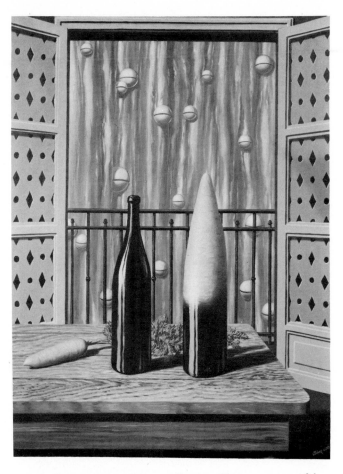

1. *L'Explication* (1952). Private collection. Photo courtesy of the Menil Foundation.

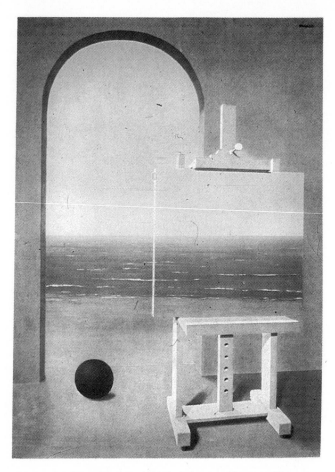

2. *La Condition humaine* (1935). Private collection. Photo courtesy of Draeger, Maître Imprimeur.

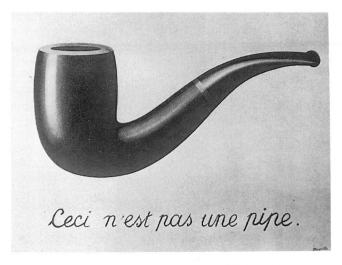

3. *Ceci n'est pas une pipe* (1926). Private collection. Photo courtesy of Draeger, Maître Imprimeur.

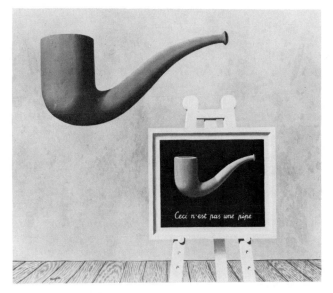

4. *Les Deux mystères* (1966). Private collection. Photo courtesy of Harry N. Abrams, Inc.

5. *Tombeau des lutteurs* (1960). Collection of Harry Torczyner. Photo courtesy of the owner.

6. *La Bataille de l'Argonne* (1959). Private collection. Photo courtesy of the Menil Foundation.

FUMÉES

Eт tandis que la guerre
Ensanglante la terre
Je hausse les odeurs
Près des couleurs-saveurs

Et je fu
m
e
du
ta
bac
de NE
Zo

Des fleurs à ras du sol regardent par bouffées
Les boucles des odeurs par tes mains décoiffées
Mais je connais aussi les grottes parfumées
Où gravite l'azur unique des fumées
Où plus doux que la nuit et plus pur que le jour
Tu t'étends comme un dieu fatigué par l'amour
Tu fascines les flammes
Elles rampent à tes pieds
Ces nonchalantes femmes
Tes feuilles de papier

7. "Fumées," by Guillaume Apollinaire.

L'ŒILLET

que cet œillet te disc
la loi des odeurs
qu'on n'a pas encore
promulguée et qui viendra
un jour
régner sur
nos cerveaux
bien +
précise & + subtile
que
les
sons
qui dirigent
Je préfère nous
ton nez
à
tous
tes
org anes ô mon amie
Il est le trône de
la
future
SA
GES
SE

8. "L'Oeillet," by Guillaume Apollinaire.

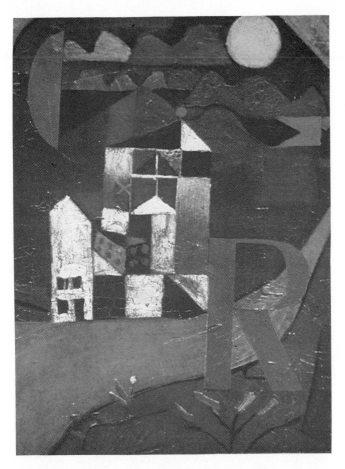

9. Paul Klee, *Villa R* (1919). Private collection. Photo courtesy of the State University of New York at Albany.

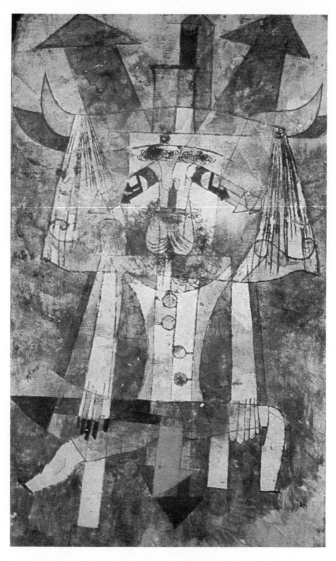

10. Paul Klee, *The Wild Man* (1922). Private collection.
Photo courtesy of the State University of
New York at Albany.

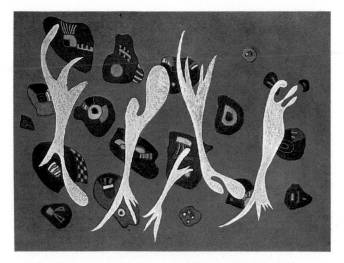

11. Wassily Kandinsky, *White Balancing* (1944). Private
collection. Photo courtesy of the State University of
New York at Albany.

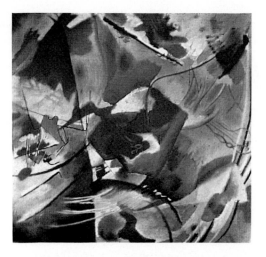

12. Wassily Kandinsky, *Improvisation: Green
Center* (1935). Private collection. Photo
courtesy of the State University of
New York at Albany.

13. *L'Incendie* (1943). Private collection. Photo courtesy of
Draeger, Maître Imprimeur.

14. *Le Séducteur* (1950). Private collection.

15. *La Philosophie dans le boudoir* (1947). Private collection. Photo courtesy of Draeger, Maître Imprimeur.

16. *L'Art de la conversation* (1950). Collection of the Galerie
Isy Brachot, Belgium.

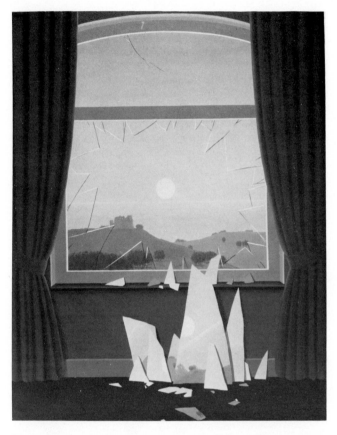

17. *Le Soir qui tombe* (1934). Collection of the Menil
Foundation, Houston.

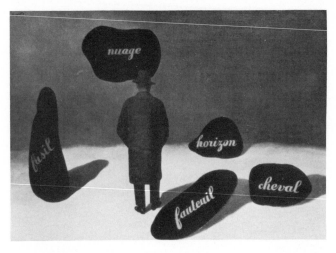

18. *Personnage marchant vers l'horizon* (1928–29). Collection of Staatsgalerie Stuttgart, Stuttgart.

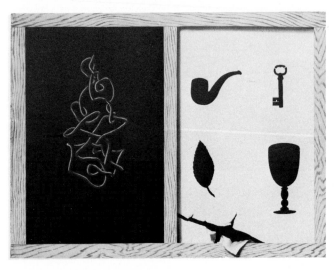

19. *L'Alphabet des révélations* (1935). Collection of the Menil Foundation, Houston.

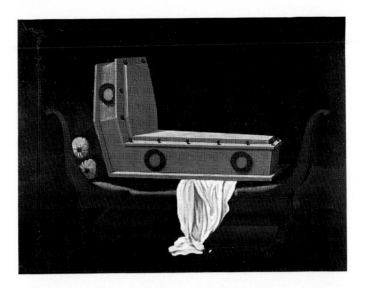

20. *Perspective: Mme. Récamier* (1958). Private collection. Photo courtesy of the State University of New York at Albany.

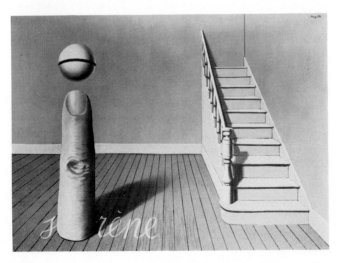

21. *L'Usage de la parole* (1932). Private collection. Photo courtesy of the owner.

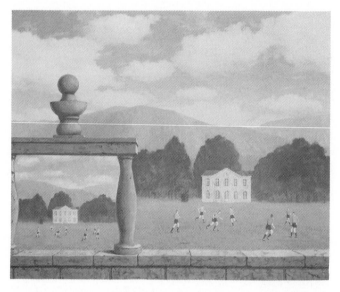

22. *Représentation* (1962). Collection of Selma and Nesuhi Ertegun. Photo courtesy of the owners.

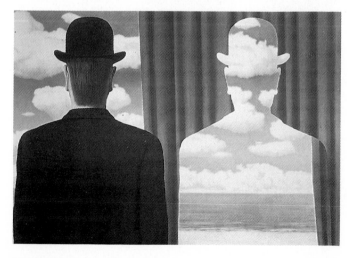

23. *Décalcomanie* (1966). Private collection. Photo courtesy of Hildegard Kron, *Omni*.

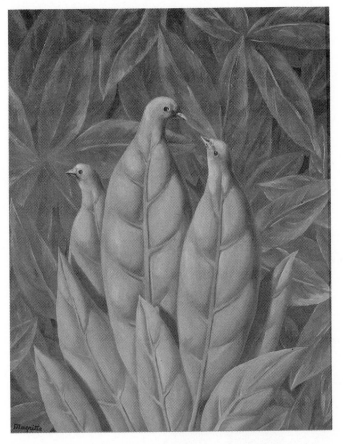

24. *Les Grâces naturelles* (1962). Private collection. Photo
courtesy of Draeger, Maître Imprimeur.

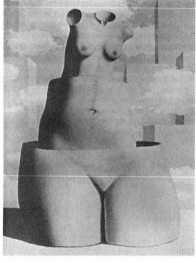

26. *Folie des grandeurs* (1961). Private collection. Photo courtesy of the State University of New York at Albany.

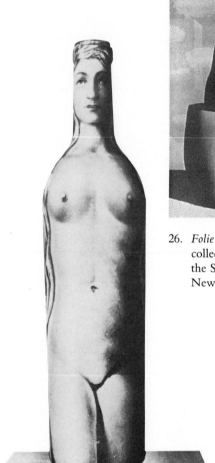

25. *La Dame,* painted bottle (1943). Collection of Harry Torczyner. Photo courtesy of the owner.

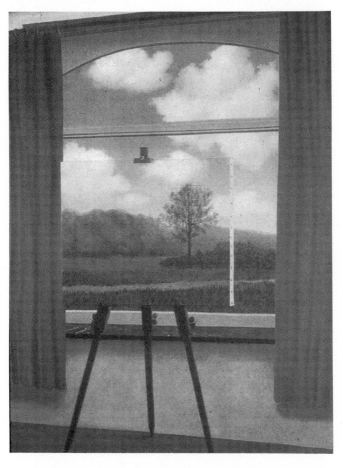

27. *La Condition humaine* ((1933). Private collection. Photo
courtesy of the State University of New York at Albany.

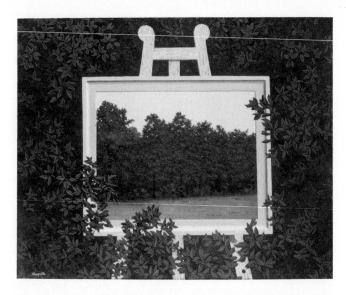

28. *La Cascade* (1961). Collection of Cavalieri Holding Co., Inc. Photo courtesy of the owner.

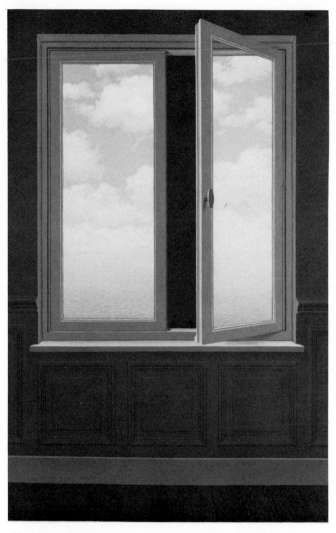

29. *La Lunette d'approche* (1963). Collection of the Menil
Foundation, Houston. Photo courtesy of the owner.

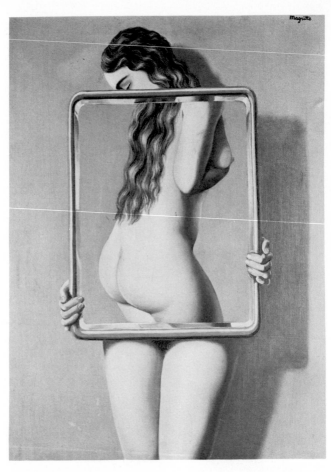

30. *Les Liaisons dangereuses* (1936). Formerly with the collection
of Galerie Octave Negru, Paris. Photo courtesy
of the Menil Foundation.